Painterly Photography

AWAKENING THE ARTIST WITHIN

Photographs and Text by Elizabeth Murray

POMEGRANATE ARTBOOKS · *San Francisco*

Front cover: *Autumn Leaves Fall—Winter Begins*, CARNAC, FRANCE
Back cover: *Solace Beside the Waterlily Garden*, GIVERNY, FRANCE
Dedication page: *Love United—Is What Love Is,* MILL VALLEY, CALIFORNIA

Published by Pomegranate Artbooks, Box 808022, Petaluma, California 94975
© 1993 Elizabeth Murray
Library of Congress Catalog Card Number 92-62862
ISBN 1-56640-601-3
Printed in Korea

Contents

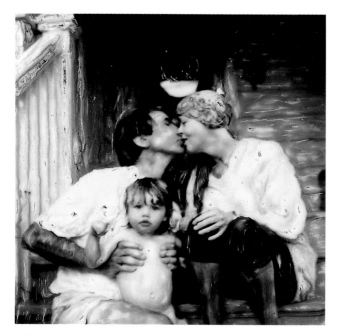

This book is dedicated with love to Jim, Pam and Rebecca Murray, whose lives are
constantly challenged and changing—yet full of love, beauty and spontaneity.
With them, each moment is appreciated and lived to the fullest.

Acknowledgments

I would like to thank some of my friends who have provided inspiration and support:

Brad Cole, who loaned me his $5 yard sale Polaroid camera and showed me how to use it

Debra Krienke Davalos, who gave me her continual support and encouragement

Ellie Rilla and Kay Cline, my "friendly nags," who gave me both prod and praise

Jeanne Cameron, my enlightened comadre and hostess of our annual artists' renewal in Maine

Kay Smith, who provided endless last-minute typing

Michael Kainer, who gave me the benefit of his great eye

John Dotson, my poet-artist friend

Ruelof Wijbrandus and Virginia Sarkis, who have helped deepen my faith

And my many supportive friends, family and patrons, especially: Catherine Alheinic; Marc Brown; Kathleen Burgy; Joan Davis; Sabine DuTertre; Yvonne Gorman; Edward Jarvis; Bill Jones; Kristin Scheel Larson; the Mallet family; Anna Rheim; my friends and fellow gardeners at Giverny; my friends who let me photograph them; and especially Tom and Katie Burke, my friends and publishers, who made this book happen

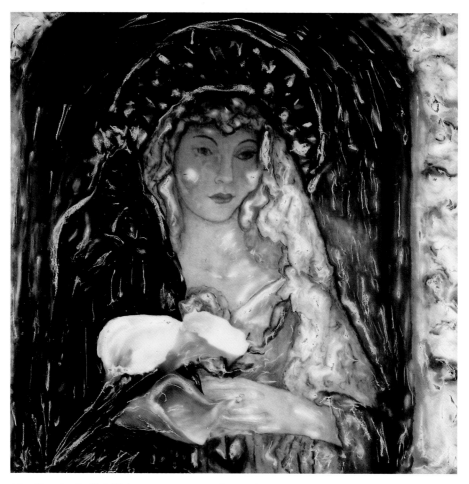

Mary Encounters the Black Madonna Santa Catalina School, Monterey, California

Awakening the Artist Within

I am in love with color and the effects of light. I love experimenting and getting personally involved with my work, and I am willing to take risks. Even though I have the patience of a gardener, I am also thrilled to get instant results.

Polaroid offers the magic of delivering my images in seconds. When I hand alter these photographs, I become more intimately involved in my images—without a darkroom. I am no longer limited to what I see in the camera's viewfinder; I can be more of a painter, truly creating my own impression of what I see and feel about a subject.

By manipulating SX-70 Polaroids, I can introduce more light and create new textures and patterns. I can develop a painter's selective eye for composition and transformation of reality. I can rub out a car or wire or anything else I don't want in my picture—I am not limited to simply cropping edges.

Painterly photography is magical, fun and completely engaging. Its spontaneous process awakens the inner artist and renews the love of playfully creating beautiful, imaginative images. And it is an opportunity to create a very personal picture with a photographic palette and paintbrush.

I like to choose a defined object, such as a building, bridge, dish, piece of furniture, boat, and so on, as a focus for my picture. Then, when I manipulate the surface of the Polaroid, everything begins to wobble a bit and lose definition. Edges blur, yet larger structural objects remain recognizable.

Usually I use toothpicks to manipulate the Polaroids while they are very soft and fluid. I place the prints under my arm while they develop, and I rewarm them there if they get too cold for the emulsion to move fluidly. When I use this immediate technique, I only photograph as many images as I have time to work on. (I also discovered that the pictures can be frozen when they are soft and defrosted later to work on.) I like working with the Polaroids when they are on a warm surface—for instance, on the top of a warm toaster oven or on the hood of a car in the sun. The softening created in this way is temporary, however; the warmed prints will actually harden faster than prints kept at room temperature.

If they are kept at room temperature, the prints harden gradually—over a couple of days—and can be worked with harder instruments, such as a metal nut pick or dental tool, with the photograph on a hard surface such as glass, marble or metal. The textures and ability to move change considerably with time. Once the prints have hardened, they cannot be made workable again by reheating.

Some prints I like just the way they are after manipulation; some I like to enhance by painting on the Polaroid after it has been manipulated. Others lend themselves to being enlarged into laser or Cibachrome prints and then heavily painted on with Marshall's photographic oils, oil pastels, inks and pencils. I find that adding more color to a color photograph is enriching rather than redundant—like adding a bouquet of flowers to a room. This collection includes some examples of photographs I have painted twice: once on the original manipulated Polaroid print and then a second time on the enlargement.

Plants, both growing freely in nature and contained in gardens, are excellent subjects to manipulate. They have naturally soft edges, delicate texture and saturated color, and light plays on them for a variety of effects. For my work with painterly photography, Claude Monet's gardens in Giverny were ideal. Not surprisingly, the elements Monet included in his gardens as subjects for his paintings are perfect for this technique. The gardens combine appealing structures with luxurious plantings and wonderful light. I took these painterly photographs of Giverny during a six-month stay in France. It was my eighth year of photographing Monet's delightful gardens. Familiarity with the subject matter allowed me greater depth of self-expression. Still lifes that I compose of favorite objects at home give me this same advantage.

We are all artists, but many of us have yet to discover our voice (means of expression) and our story or message. Everyone's story is important to the creative process. Play, spontaneity, fun and a belief in the process of self-expression—even the unbeautiful—are essential to keep creativity alive and well. Painterly photography can help awaken the creative spirit. I have worked in this medium with people of all ages, from young children to senior citizens. They have all been thrilled with the process and delighted with their varied results. Some abstract their images with blurred photographs to begin with, while others create very tight patterns and textures. I like to blur and merge edges and allow images to soften as I bring in more light and color. Whatever style emerges for you, I am sure you will find painterly photography an enriching, rewarding and enjoyable process.

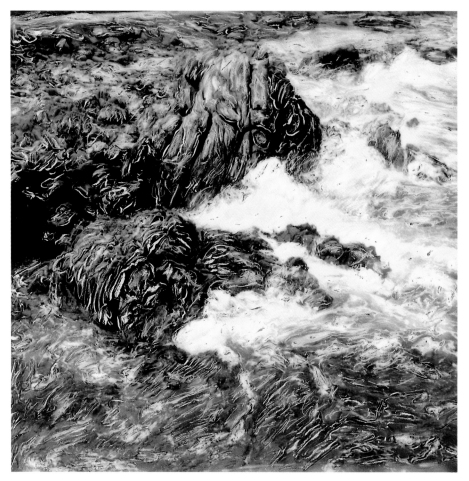

Wind from the Sea to Rocky Point BIG SUR, CALIFORNIA

SEASCAPES

Edges of Land and Water—
The Conscious and the Unconscious

NATURALLY FLUID SCENES ARE

EMBELLISHED NATURALLY WITH

PAINTERLY PHOTOGRAPHY.

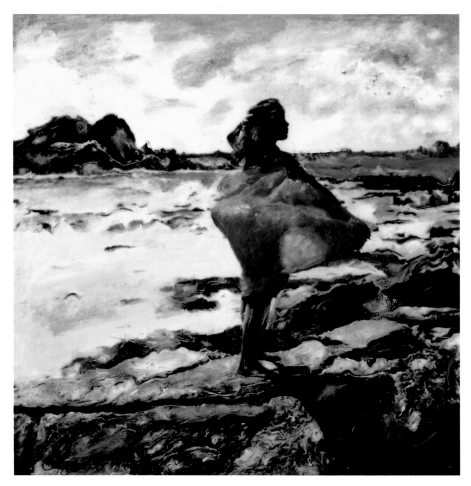

Child of Wind and Sea ROSCOFF, FRANCE

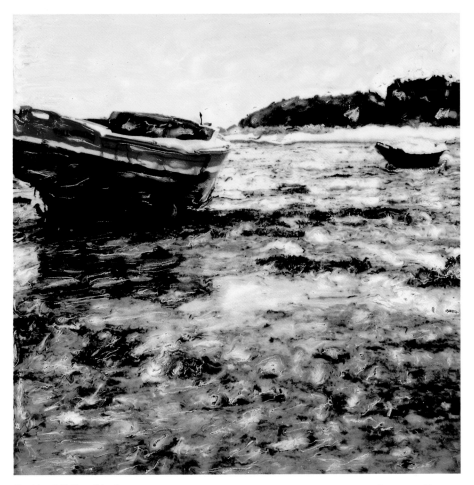

You May Still Sing of the Sea ROSCOFF, FRANCE

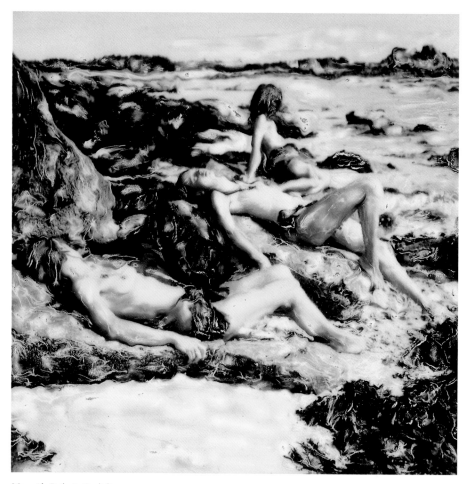

Mermaids Bathe in Sunlight

ROSCOFF, FRANCE

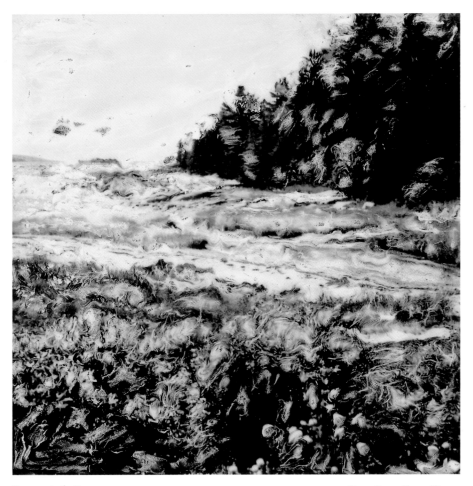

Evergreen to the Sea EAST BLUE HILL, MAINE

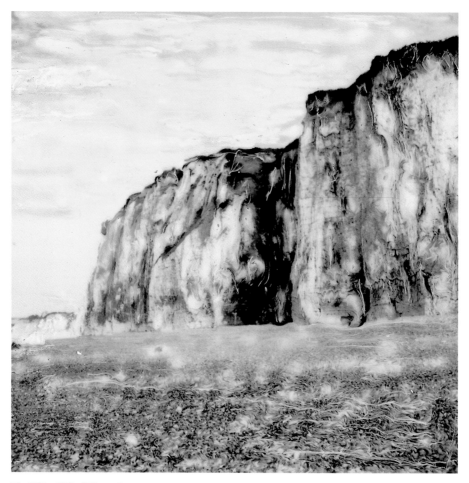

The White Cliffs of Normandy VARENGEVILLE-SUR-MER, FRANCE

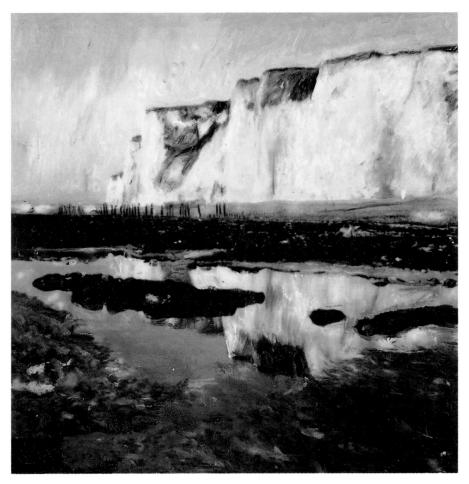

Reflections of Golden Light VARENGEVILLE-SUR-MER, FRANCE

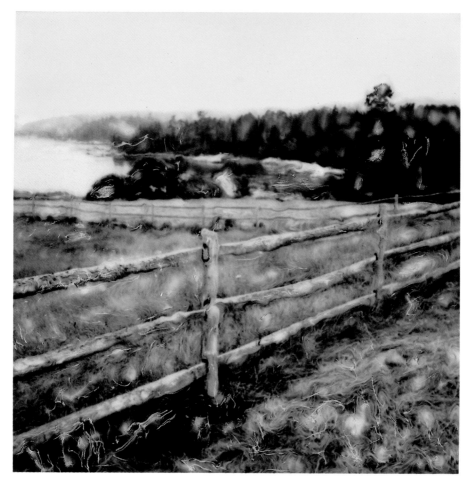

The Swimming Cove

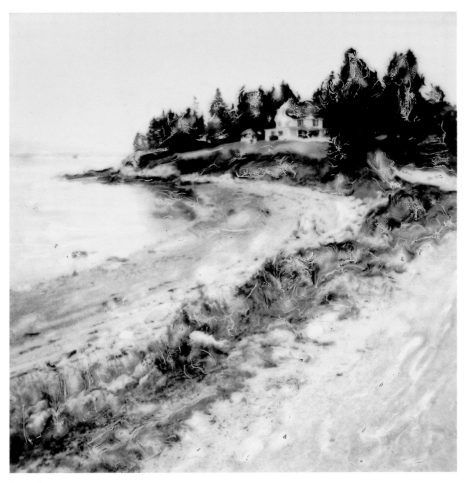

Home Coming HARBORSIDE, MAINE

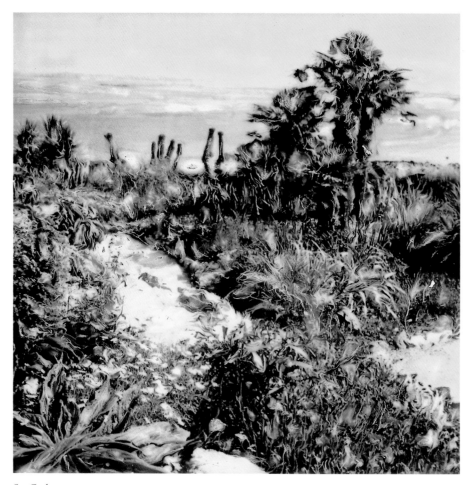

Sea Garden　　　　　　　　　　　　　　　　　　　　　　　ROSCOFF, FRANCE

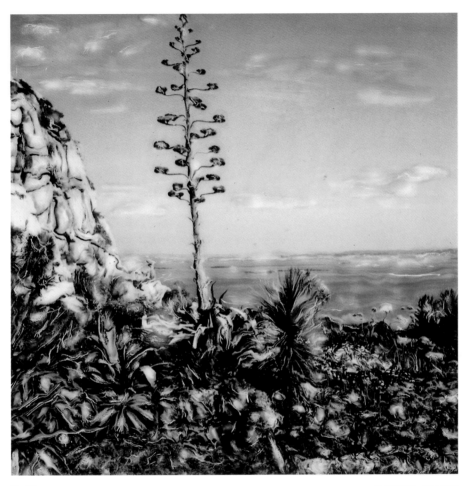

Sea View

ROSCOFF, FRANCE

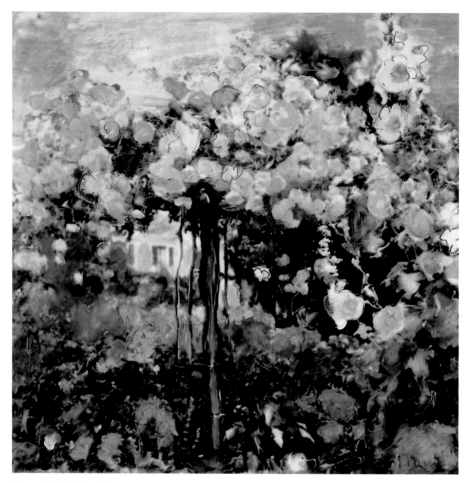

Giverny in Pink Rose Light

GARDENS

*Private Sanctuaries—Inspiration
for the Soul*

GARDENS NATURALLY SOFTEN EDGES WITH

TAPESTRY-LIKE WEAVINGS OF COLOR,

TEXTURE AND FORM. LIKE IMPRESSIONIST

PAINTING, PAINTERLY

PHOTOGRAPHY EMPHASIZES THIS

BLURRING AND SOFTENING.

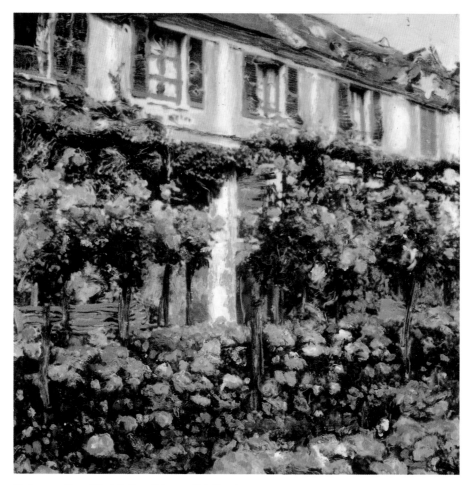

It's Summer: Queen Elizabeth Roses Reign over Pink Geraniums

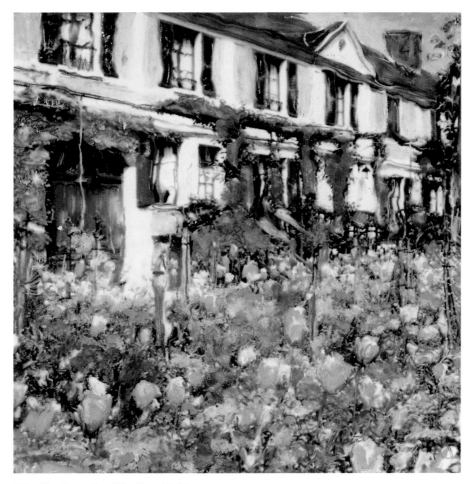

Tulips Rise Above a Sea of Blue Forget-Me-Nots GIVERNY, FRANCE

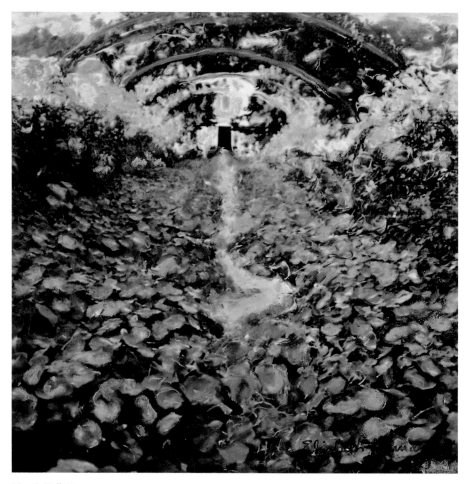

Monet's Walk Home

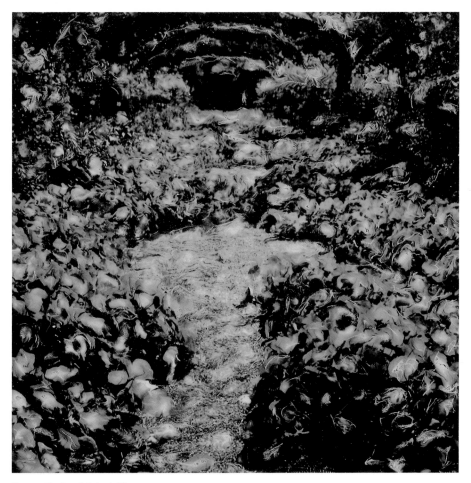

Summer Garden of Stained Glass

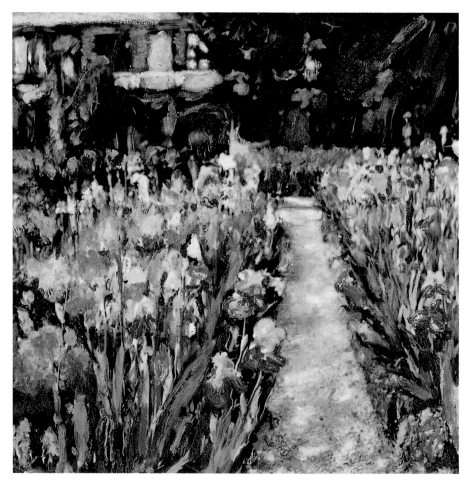

Iris Path of Light

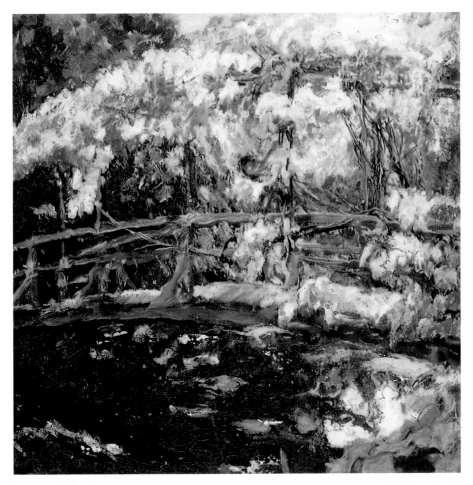

The Tangled, Flowering Green Footbridge <small>GIVERNY, FRANCE</small>

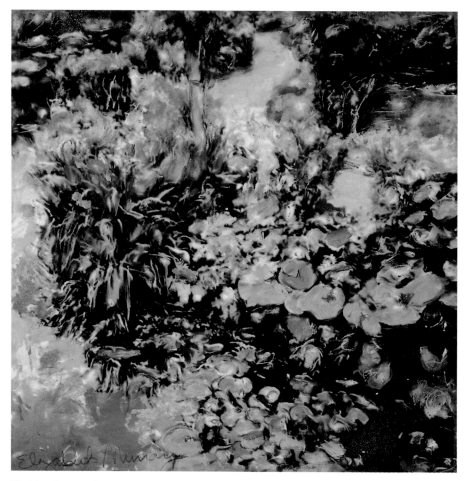

The Moist Fragrance of Green

GIVERNY, FRANCE

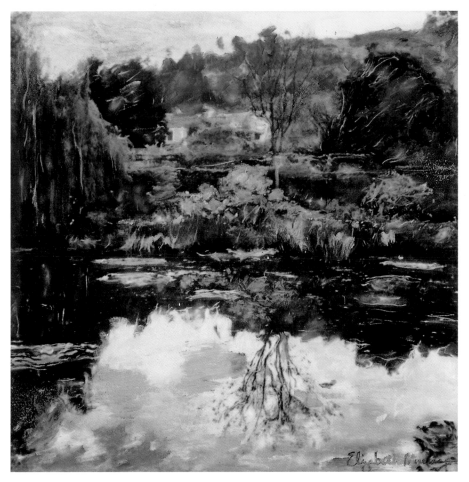

Water Tapestry GIVERNY, FRANCE



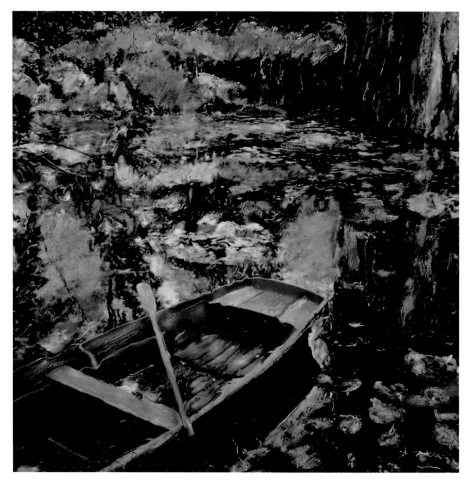

Green Boat Awaits to Explore the Iridescent Light

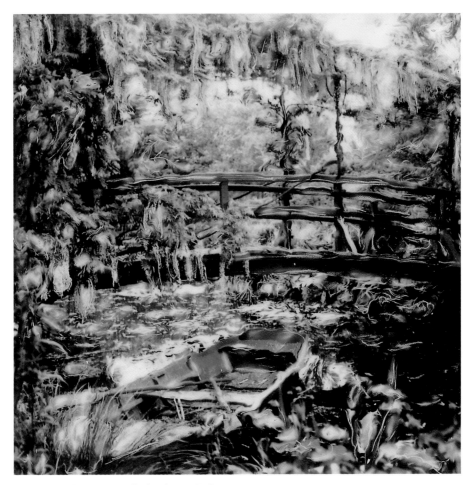

The Water Gardener's Boat Under the Blooming Bridge

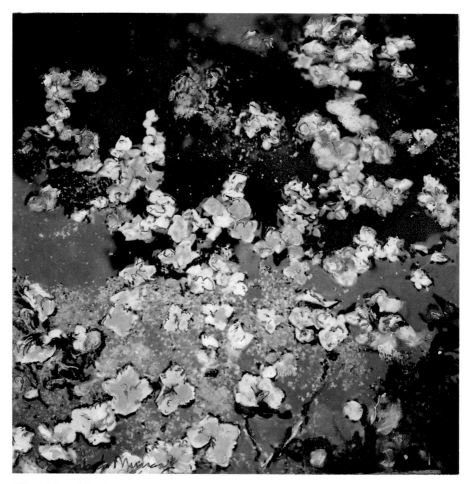

Whispered Song of the Water VARENGEVILLE-SUR-MER, FRANCE

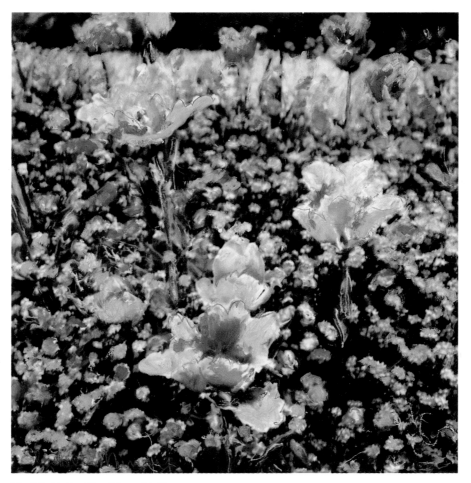

The Light Touches All and Forgets-Me-Not

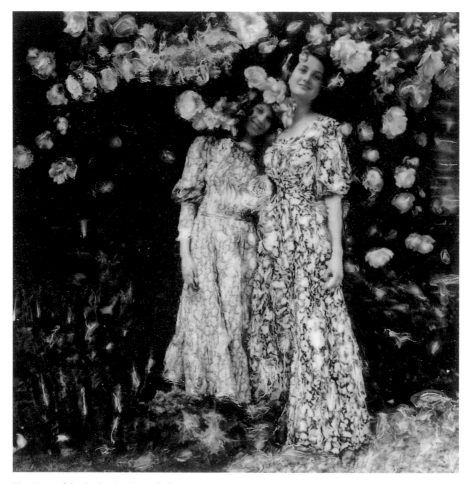

Two Sisters of the Garden: Daphne and Alice Parc Floral des Moutiers, Varengeville, France

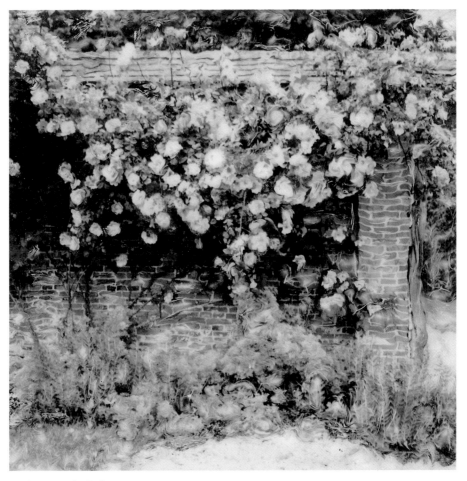

On the Way to the Garden PARC FLORAL DES MOUTIERS, VARENGEVILLE, FRANCE

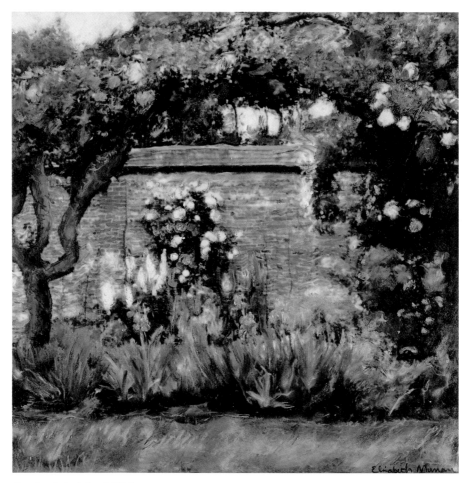

Blooming Apple Arch and Old Roses PARC FLORAL DES MOUTIERS, VARENGEVILLE, FRANC

38

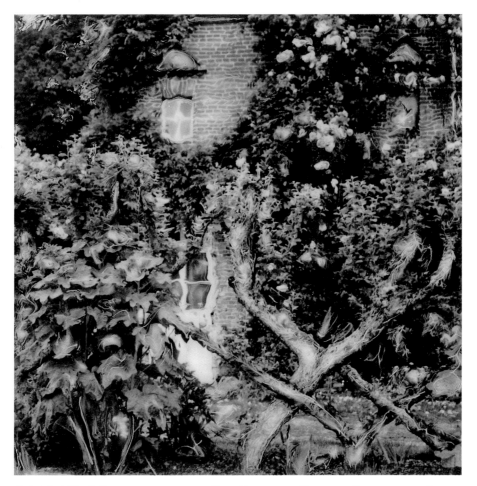

Ancient Apple Tree Lattice Parc Floral des Moutiers, Varengeville, France

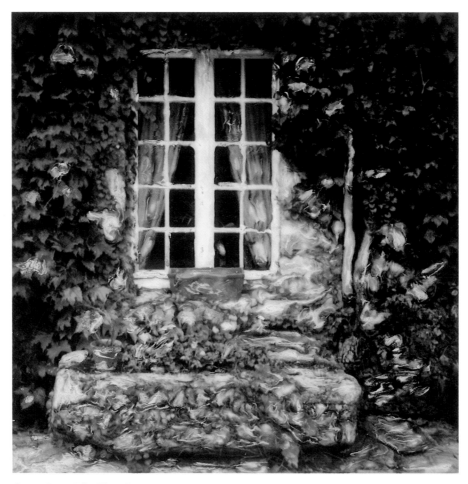

Autumn Leaves Fall—Winter Begins

CARNAC, FRANCE

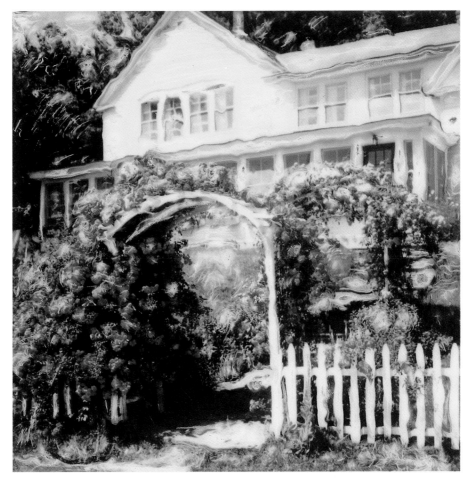

Rose Bowers Lead Home HARBORSIDE, MAINE

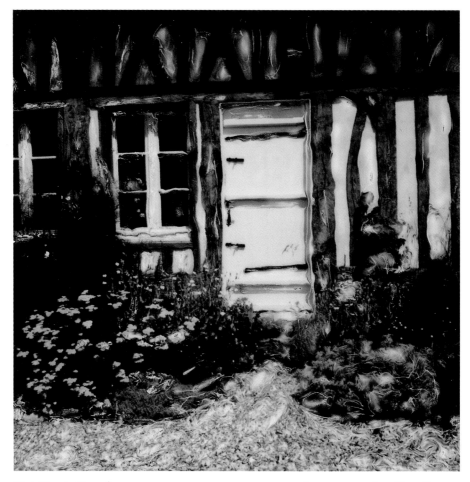

Marc's Home in Normandy

ARCHITECTURE
AND EXTERIORS

*Structures Created for Shelter and
Personal Expression of Space;
Found Compositions of Human-Made
Relics Informally Placed in Nature*

THE HARD EDGES OF ARCHITECTURE AND

THE ROUNDED LINES OF THESE FOUND

OBJECTS SOFTEN BEAUTIFULLY WITH

MANIPULATION YET STILL HOLD THEIR FORM.

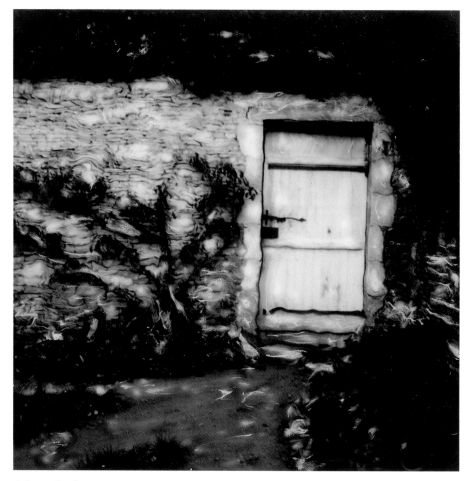

A Door to Paradise

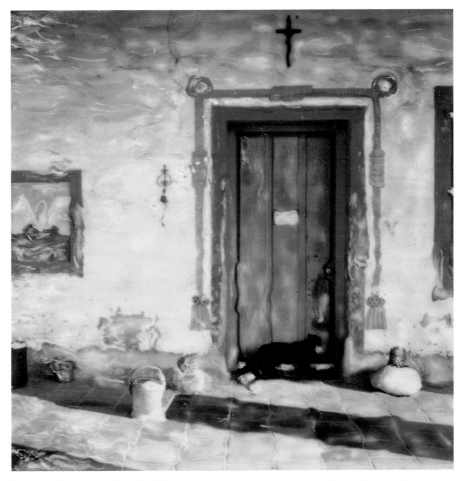

Beyond the Green Door Awaits a Black Cat Mission San Antonio de Padua, Jolon, California

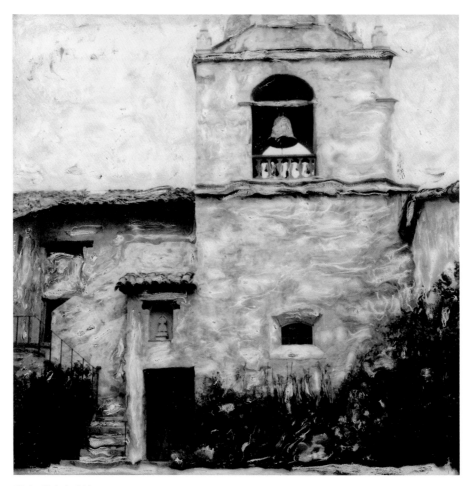

Giving Back the Light

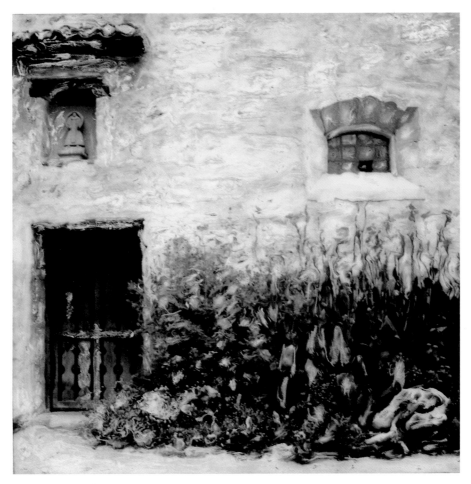

Window to Garden of Light CARMEL MISSION, CARMEL, CALIFORNIA

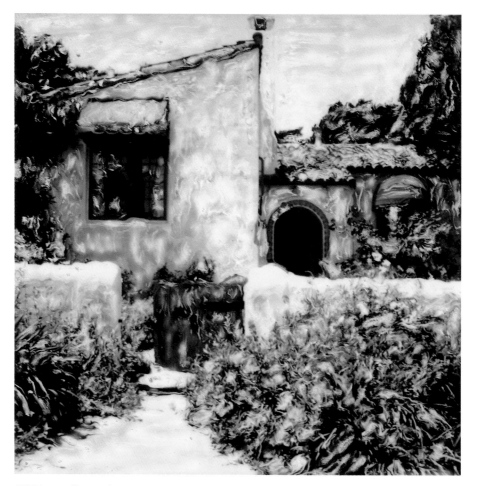

Old Monterey Illuminated

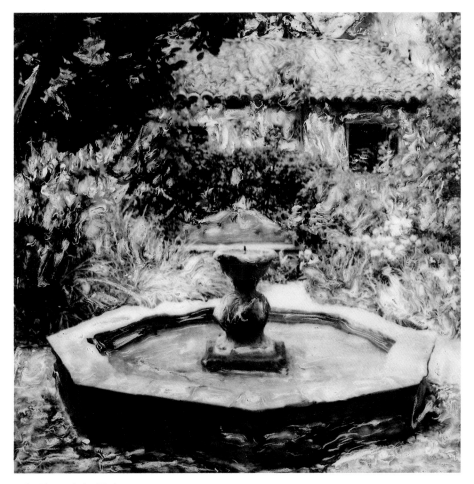

Color Blows with the Wind CARMEL MISSION, CARMEL, CALIFORNIA

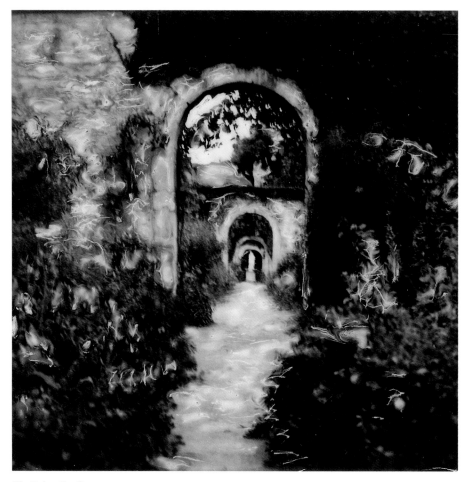

The Path to Paradise

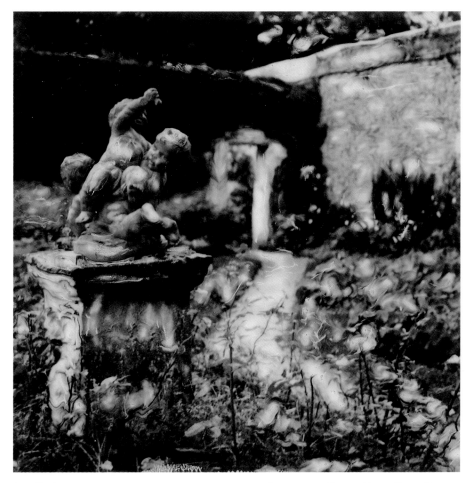

Inner Sanctum CHATEAU DE CANON NEAR CAEN, FRANCE

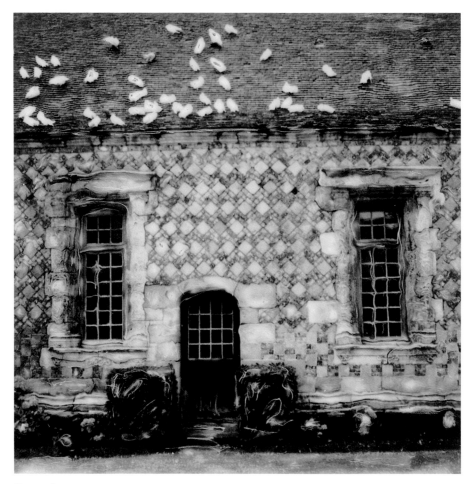

Doves at Peace LE MANOIR D'ANGO, VARENGEVILLE-SUR-MER, FRANCE

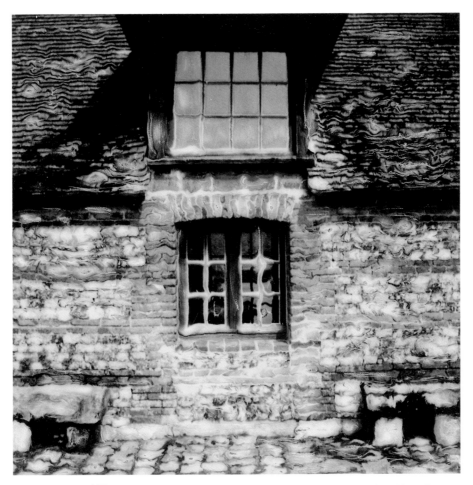

Luminous Pattern and Texture

Le Manoir d'Ango, Varengeville-Sur-Mer, France

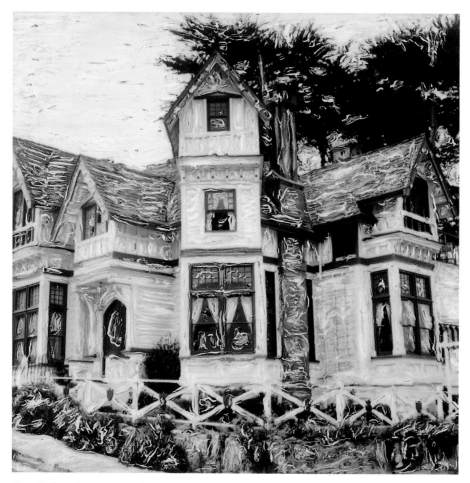

Green Gables and Every Room with a Sea View

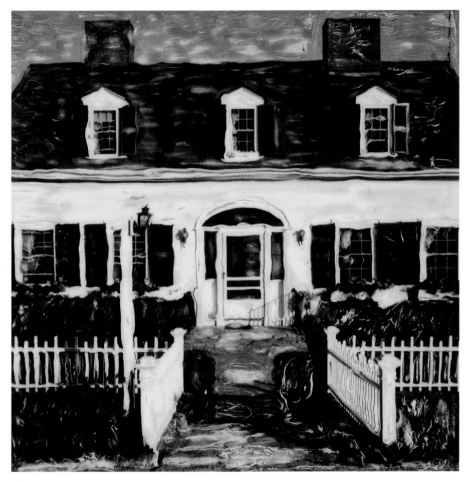

The Maine House

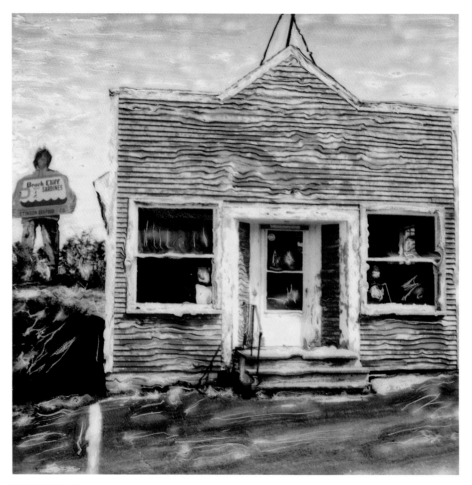

Beach Cliff Sardines

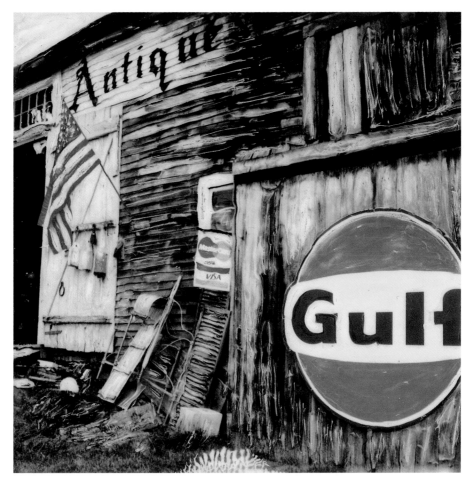

All-American Antiques

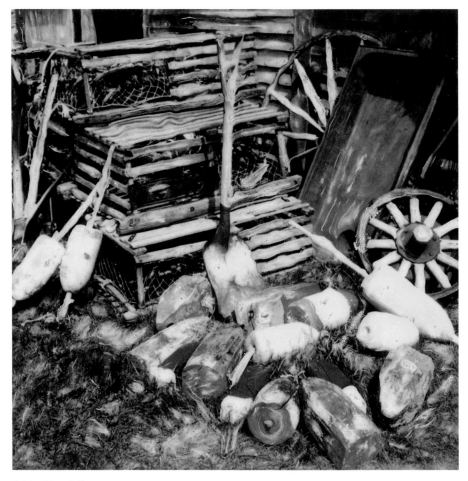

Lobster Pots and Traps DEER ISLE, MAINE

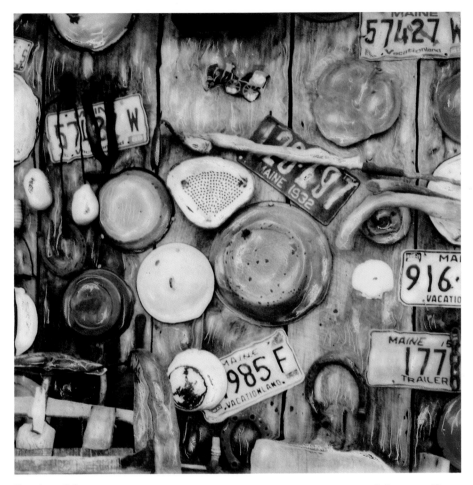

Enamelware Collage

A SHACK IN MAINE

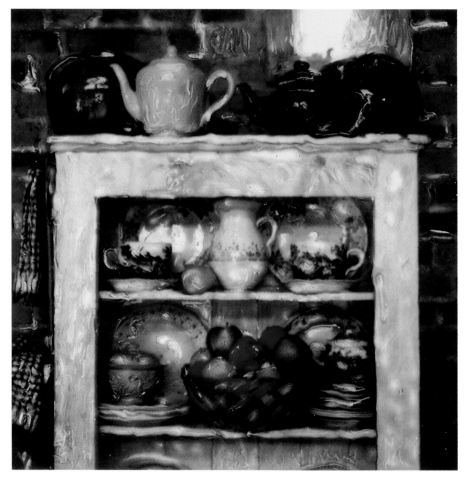

Lizzie's French Kitchen VARENGEVILLE-SUR-MER, FRANCE

STILL LIFES AND INTERIORS

Private Rooms, Furniture and Decorative Objects, Fruits and Flowers

SUBJECT MATTER FAVORED BY

PAINTERS IS ALSO IDEAL FOR

PAINTERLY PHOTOGRAPHY.

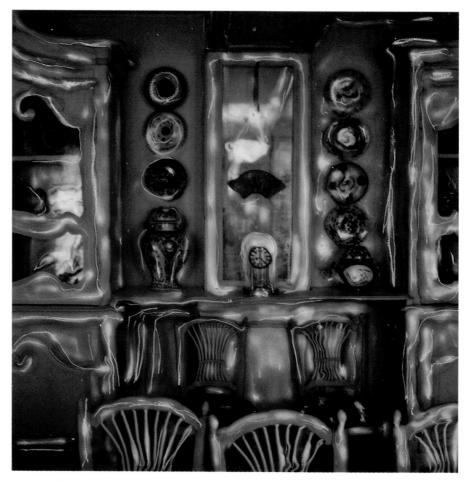

Time for Reflection

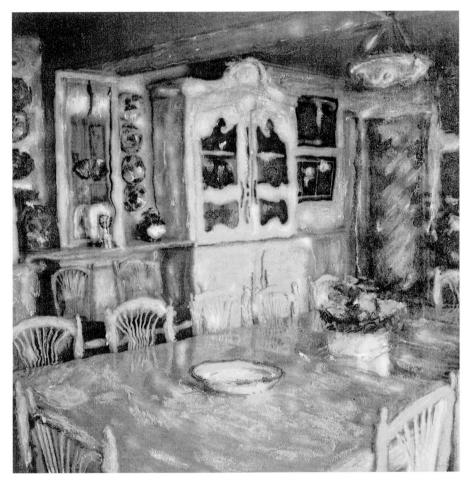

Golden Light in Monet's Dining Room

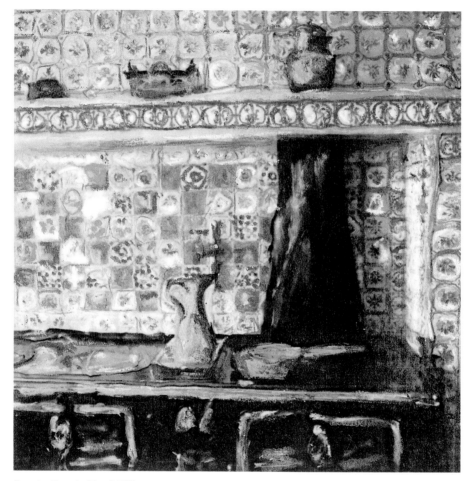

Preparing Feasts for Monet's Table

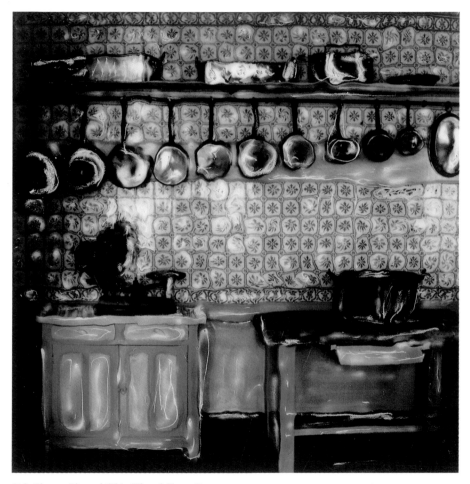

Light Plays on Blue-and-White Tile and Copper Pots　　　　　　　　　　　GIVERNY, FRANCE

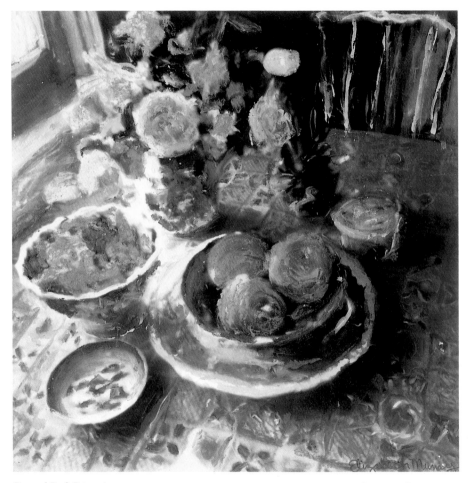

Rose and Peach Potpourri

 CARMEL, CALIFORNIA

 66

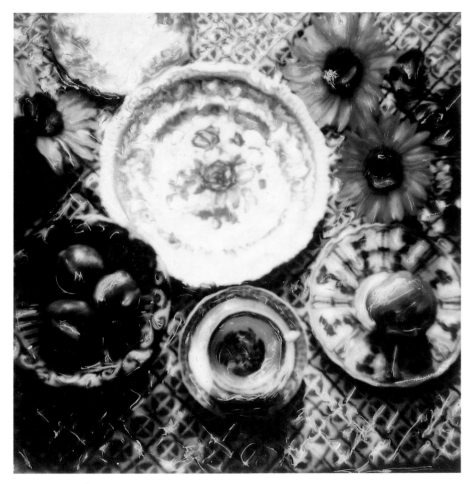

Summer in the Kitchen Carmel, California

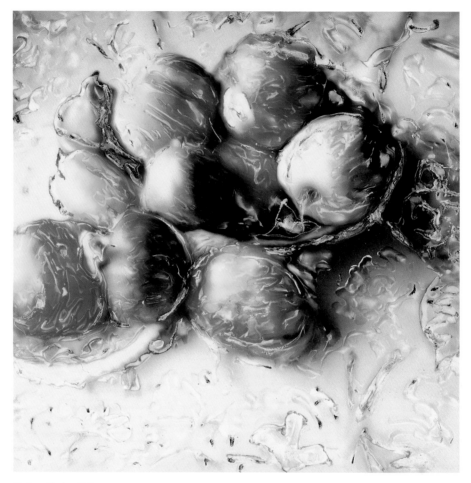

Fruit on Shadow Patterns

CARMEL, CALIFORNIA



68

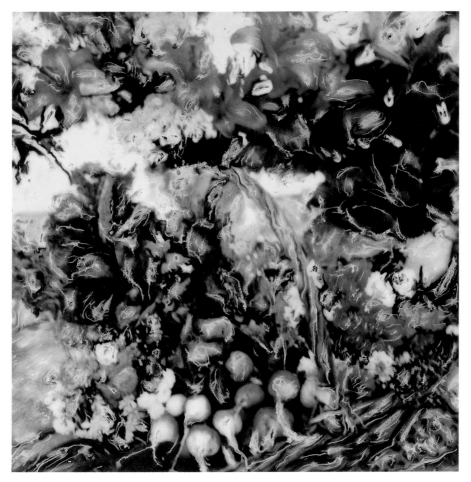

Gifts from the Farmer's Market

BLUE HILL, MAINE

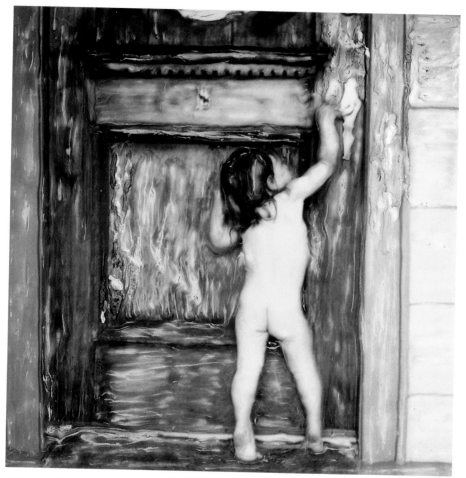

Rebecca at the Door

PEOPLE

Portraits—A Classic Subject for Artists

THE CHALLENGES ARE TO CAPTURE THE
LIKENESS OF THE PERSON IN THE FULL
RADIANCE OF THE MOMENT AND TO
REFLECT THE ARTIST'S VISION. PAINTERLY
PHOTOGRAPHY ENABLES ONE TO DO BOTH.

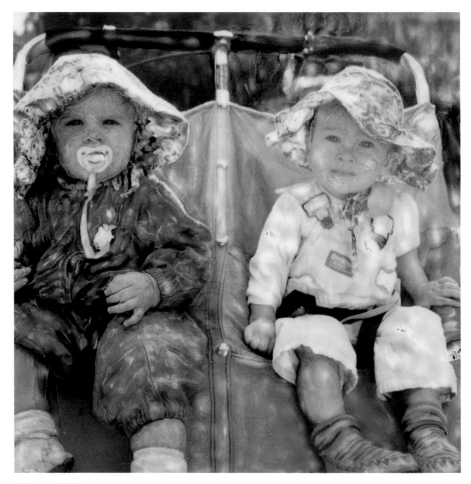

Sisters on a Stroll MILL VALLEY, CALIFORNIA

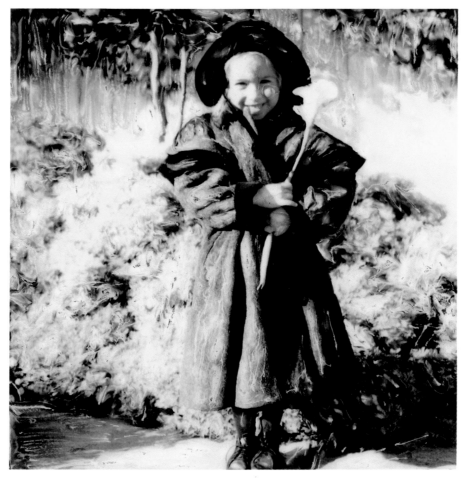

Miss Jill CARMEL, CALIFORNIA

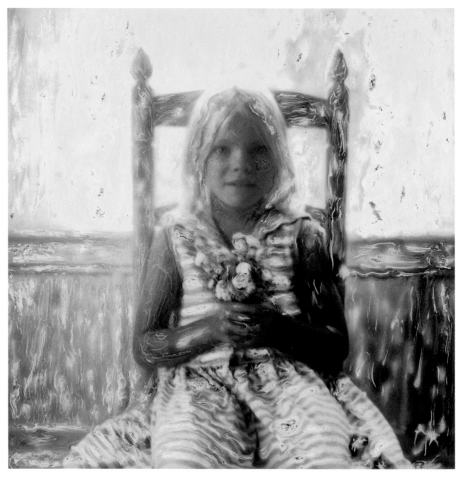

Ebony in the Light

BLUE HILL, MAINE

74

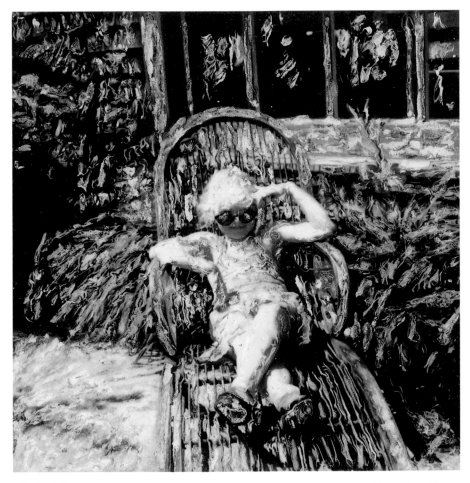

Life of Rachel

The Stories Behind the Images

BACK COVER *Solace Beside the Waterlily Garden*
GIVERNY, FRANCE
This bench was one of Monet's favorite places to observe the changing light on his inspirational water garden. The image was altered immediately with wooden tools. No color was applied.

PAGE 4 *Love United—Is What Love Is*
MILL VALLEY, CALIFORNIA
This photograph was frozen immediately after the image became visible. Two weeks later I warmed it on the top of a toaster oven set at 200°F (if the temperature is any higher, the photograph will wrinkle and the emulsion will bubble). I like working with a fluid emulsion so I can be very careful not to distort faces. I used a pointed metal tool for detail and a wooden one for softer lines.

PAGE 6 *Mary Encounters the Black Madonna*
SANTA CATALINA SCHOOL, MONTEREY,
CALIFORNIA
For this photograph a Mexican Black Madonna statue with white calla lilies was hand held in front of a 1920s fresco on an old stucco wall. I warmed the print under my arm to keep the emulsion fluid and manipulated it on the spot with a toothpick.

PAGE 10 *Wind from the Sea to Rocky Point*
BIG SUR, CALIFORNIA

I kept this print warm under my arm and worked some areas immediately with a toothpick. Later, at home, I went into greater detail with a pointed metal tool.

PAGE 12 *Child of Wind and Sea*
ROSCOFF, FRANCE
This image was worked with a toothpick immediately. I enlarged the original Polaroid with a laser print to 11 x 11 inches. I then painted the copy with Marshall's photographic oils and French oil pastels.

PAGE 13 *You May Still Sing of the Sea*
ROSCOFF, FRANCE
I manipulated this photograph with a toothpick immediately after the image appeared.

PAGE 14 *Mermaids Bathe in Sunlight*
ROSCOFF, FRANCE
I took care not to disfigure the mermaids' bodies with heavy alteration, yet I wanted to incorporate painterly texture and blend them into their sea environment. I manipulated the photograph immediately with wooden tools.

PAGE 15 *Evergreen to the Sea*
EAST BLUE HILL, MAINE
This image was worked immediately with a toothpick, frozen, and then worked again with a metal instrument on a warm toaster oven.

PAGE 16 *The White Cliffs of Normandy*
VARENGEVILLE-SUR-MER, FRANCE
I worked this photograph with a toothpick immediately, warming it under my arm to keep the emulsion soft.

PAGE 17 *Reflections of Golden Light*
VARENGEVILLE-SUR-MER, FRANCE
After manipulation of this image was complete, I enlarged it to 11 x 11 inches with a laser print and then painted it with Marshall's photographic oils and French oil pastels.

PAGE 18 *The Swimming Cove*
EAST BLUE HILL, MAINE &
PAGE 19 *Home Coming,* HARBORSIDE, MAINE
Both of these images were taken with a plastic Polaroid One-Step Land Camera with no focusing ability (purchased for $5 at a garage sale). They were both worked immediately with a toothpick. It was a warm day, so the emulsion remained very fluid. With the limitation of control for focus, zoom, light readings, and so on, I took extra care to create a pleasing painterly-style composition of one-third sky, two-thirds land and a curving path for the eye to follow to the point of interest. The flat gray light and softly blended edges add to the painterly effect.

PAGE 20 *Sea Garden,* ROSCOFF, FRANCE &
PAGE 21 *Sea View,* ROSCOFF, FRANCE
Both images were taken in the late morning of a sunny day in Brittany. The colors were saturated but not faded by too much light. I worked the images immediately with toothpicks.

PAGE 22 *Giverny in Pink Rose Light*
GIVERNY, FRANCE
This photograph was taken on a gray day and worked immediately with a toothpick. I liked the composition but was disappointed by the lack of color. To remedy this, I colored the original Polaroid with photographic oil paints, then I enlarged it with a laser print to 11 x 11 inches and painted it a second time with photographic oils, pencils and oil pastels. The image blossomed into a very romantic and personal view of Monet's garden.

PAGE 24 *It's Summer: Queen Elizabeth Roses Reign over Pink Geraniums,* GIVERNY, FRANCE
Here I manipulated the image immediately with wooden instruments. The original was painted on, then enlarged and painted on a second time, as with *Giverny in Pink Rose Light.*

PAGE 25 *Tulips Rise Above a Sea of Blue Forget-Me-Nots,* GIVERNY, FRANCE
The emulsion on this Polaroid was moved immediately. Later the original was painted with photographic oils.

PAGE 26 *Monet's Walk Home*
GIVERNY, FRANCE
This photograph was manipulated immediately with toothpicks and then painted twice—first on the original Polaroid and then on the enlarged print.

PAGE 27 *Summer Garden of Stained Glass*
GIVERNY, FRANCE
This scene was captured when the sun was

setting with a golden glow and was low enough to backlight all the nasturtium leaves. I colored the original to highlight this naturally illuminated effect.

PAGE 28 *Iris Path of Light,* GIVERNY, FRANCE
This photograph was manipulated immediately with toothpicks and painted twice, the original with photographic oils and the enlargement with oil pastels, oils, inks and pencils.

PAGE 29 *The Tangled, Flowering Green Footbridge,* GIVERNY, FRANCE
Edges were softened with wooden tools while the emulsion was fluid, then the image was enlarged with a laser print to 8 x 8 inches. The print was then colored with pencils, inks and French oil pastels, including iridescent colors.

PAGE 30 *The Moist Fragrance of Green* GIVERNY, FRANCE
The original, altered immediately with toothpicks, was painted with photographic oils, and the laser enlargement with photographic oils and oil pastels.

PAGE 31 *Water Tapestry,* GIVERNY, FRANCE
The photograph was manipulated immediately with a toothpick, then both the original and the laser print enlargement (11 x 11 inches) were painted with photographic oils, pencils, inks and oil pastels.

PAGE 32 *Green Boat Awaits to Explore the Iridescent Light,* GIVERNY, FRANCE
The original was manipulated immediately

while very fluid, and then the laser print enlargement was rendered with oil pastels, oil paints, inks and pencil.

PAGE 33 *The Water Gardener's Boat Under the Blooming Bridge,* GIVERNY, FRANCE
Manipulated with a toothpick while still soft, this photograph already contained such saturated colors and such a painterly image that I felt no other work was necessary.

PAGE 34 *Whispered Song of the Water* VARENGEVILLE-SUR-MER, FRANCE
This abstracted view of hydrangea blossoms floating on a pond with duckweed was manipulated with toothpicks while still warm. The laser-enlarged print was painted with oils, inks, pencil and iridescent oil pastels.

PAGE 35 *The Light Touches All and Forgets-Me-Not,* GIVERNY, FRANCE
Rose pink tulips blooming with blue forget-me-nots have a textile-like quality. The process used here was the same as for *Whispered Song of the Water.*

PAGE 36 *Two Sisters of the Garden: Daphne and Alice,* PARC FLORAL DES MOUTIERS, VARENGEVILLE, FRANCE
A moment of utter romance was captured with Alice and Daphne when they put on their grandmother's dresses and I photographed them under full-blown roses. I worked the emulsion while soft with toothpicks, being careful not to distort their faces. Later I painted the original with photographic

oils to embellish the old-fashioned, painterly quality of this image.

PAGE 37 *On the Way to the Garden*
PARC FLORAL DES MOUTIERS, VARENGEVILLE, FRANCE
The coral old-fashioned climbing rose "Meg" complemented the 100-year-old brick wall beautifully. Photographic oils were used to accent the colors and further soften the edges.

PAGE 38 *Blooming Apple Arch and Old Roses*
PARC FLORAL DES MOUTIERS, VARENGEVILLE, FRANCE
This hand-colored blurred-edged photograph was enlarged and re-colored with oil pastels, pencils and inks.

PAGE 39 *Ancient Apple Tree Lattice,* PARC FLORAL DES MOUTIERS, VARENGEVILLE, FRANCE
Following initial manipulation of the still-fluid emulsion, the original photograph was enhanced with photographic oils.

PAGE 40 & FRONT COVER *Autumn Leaves Fall—Winter Begins,* CARNAC, FRANCE
This photograph, manipulated with toothpicks immediately after it was taken, has had no color added.

PAGE 41 *Rose Bowers Lead Home*
HARBORSIDE, MAINE
Kept warm on the sunny dashboard of the car, the Polaroid original was later manipulated with a metal nut pick on the warm hood of the car to soften all the architectural lines.

PAGE 42 *Marc's Home in Normandy*
VARENGEVILLE-SUR-MER, FRANCE
My friend's fourteenth-century cottage, with its curved exposed beams and white stucco, provided a perfect image to manipulate.

PAGE 44 *A Door to Paradise*
CHATEAU DE CANON NEAR CAEN, FRANCE
This wooden door in an eighteenth-century stone wall leads to thirteen different garden rooms. The manipulation, done with toothpicks while the emulsion was still warm, exaggerates the dappled light effect along the textured surfaces.

PAGE 45 *Beyond the Green Door Awaits a Black Cat*
MISSION SAN ANTONIO DE PADUA, JOLON, CALIFORNIA
I was fortunate to catch this cat on her stroll past the door of this eighteenth-century mission. The detail, saturation of color and strong structural elements of this photograph make it a perfect subject for manipulation, which I accomplished in the soft emulsion with a toothpick. I later colored the original print with photographic oils to enrich the colors and the light effects.

PAGE 46 *Giving Back the Light*
CARMEL MISSION, CARMEL, CALIFORNIA &
PAGE 47 *Window to Garden of Light*
CARMEL MISSION, CARMEL, CALIFORNIA
Both of these images were manipulated with toothpicks while they were fresh and fluid. Later I painted them with photographic oils to enhance the colors and textures of the old

walls and gardens of this celebrated mission (established 1770). Photographic oils are rubbed into the print with a cotton swab rather than laid on with a brush, which makes this an ideal way to enrich texture.

PAGE 48 *Old Monterey Illuminated*
MONTEREY, CALIFORNIA
The blue and orange accents of this 1920s mission revival stucco house and its lush gardens were delightful to alter.

PAGE 49 *Color Blows with the Wind*
CARMEL MISSION, CARMEL, CALIFORNIA
This photograph and *Old Monterey Illuminated* share a similar ambience, with highly textured plaster walls, Spanish tile roofs and lush plantings animated with dappled light. I manipulated each with toothpicks while its emulsion was warm and fluid. Then I painted the originals with oils to embellish the luminous feeling and mood.

PAGE 50 *The Path to Paradise*
CHATEAU DE CANON NEAR CAEN, FRANCE &
PAGE 51 *Inner Sanctum,* CHATEAU DE CANON NEAR CAEN, FRANCE
Six arches frame a view of Pomona, the goddess of fruit trees, and create thirteen orchard rooms filled with fruit and flowers. It had been storming for hours the day I visited this eighteenth-century chateau, but the sun broke for a few minutes and I quickly took these shots. The long-awaited sunlight sparkled on the wet paths and stone walls. These photographs were manipulated immediately with toothpicks.

PAGE 52 *Doves at Peace,* LE MANOIR D'ANGO, VARENGEVILLE-SUR-MER, FRANCE &
PAGE 53 *Luminous Pattern and Texture* LE MANOIR D'ANGO, VARENGEVILLE-SUR-MER, FRANCE
Built in the sixteenth century by Italian artisans for French pirates, these buildings incorporate stone collected on the beaches (see pp. 16 and 17). They were the perfect subject for gentle manipulation with toothpicks, accenting the textures and softening the stone edges. No color was added.

PAGE 54 *Green Gables and Every Room with a Sea View,* PACIFIC GROVE, CALIFORNIA (built in 1888) &
PAGE 55 *The Maine House,* EAST BLUE HILL, MAINE (built in 1788)
Each of these white wooden houses has a splendid sea view and great charm. The distinctive architectural lines provided many edges to soften without losing the form. Both photos were manipulated within a couple of hours of shooting with a pointed metal tool.

PAGE 56 *Beach Cliff Sardines*
SEAL HARBOR, MAINE &
PAGE 57 *All-American Antiques*
BAR HARBOR, MAINE
I like the humor, colors, textures and shapes of the juxtaposition of the objects in these scenes. The rich reds were well captured with the Polaroid film. These prints were kept on the sunny dashboard of the car and then manipulated with a metal nut pick on the warm hood of the car, which allowed for

very fluid movement of emulsion. No color was added.

PAGE 58 *Lobster Pots and Traps* DEER ISLE, MAINE &
PAGE 59 *Enamelware Collage,* A SHACK IN MAINE
The artful collections of lobstermen gave me many shapes, textures, and colors to manipulate. I kept these images warm and fluid in the sun, then froze them for a week until I had time to work on them. I moved the emulsion with a metal nut pick on the top of a warm toaster oven. The bright yet overcast day provided very saturated colors.

PAGE 60 *Lizzie's French Kitchen* VARENGEVILLE-SUR-MER, FRANCE
Natural light dappled the patterns of my favorite blue-and-white dishes and basket of fruit. The manipulations with toothpicks accentuated the light and softly merged all the edges.

PAGE 62 *Time for Reflection,* GIVERNY, FRANCE &
PAGE 63 *Golden Light in Monet's Dining Room* GIVERNY, FRANCE
These prints radiate with Monet's passion for light. Japanese blue-and-white china helps create a warm, welcoming room for feasting. I photographed with available light, so *Time for Reflection* came out quite dark. I added light and more definition by scratching the emulsion down to the white surface. *Golden Light in Monet's Dining Room* I enlarged and painted on with metallic, iridescent oil pastels, inks and pencils to enhance the sparkling light quality.

PAGE 64 *Preparing Feasts for Monet's Table* GIVERNY, FRANCE &
PAGE 65 *Light Plays on Blue-and-White Tile and Copper Pots,* GIVERNY, FRANCE
Both of these photographs of Monet's kitchen were taken with available light and manipulated with toothpicks while fresh. *Preparing Feasts* was enlarged with a laser copier and painted with oil pastels, inks and pencils. *Light Plays* has no added color.

PAGE 66 *Rose and Peach Potpourri* CARMEL, CALIFORNIA
Still lifes created at home have the advantage of being composed of objects we know and love in familiar light. Saturated color, distinctive shapes and multiple patterns are excellent elements to manipulate. This picture was moved with toothpicks when soft, then enlarged and painted with oil pastels, inks, pencil and watercolor.

PAGE 67 *Summer in the Kitchen* CARMEL, CALIFORNIA
I stood on a chair to get this bird's-eye view of the table, which flattened the objects on it and gave them more pattern and shape.

PAGE 68 *Fruit on Shadow Patterns* CARMEL, CALIFORNIA
The fruit photographed with rich colors, but the tablecloth was washed out. I decided to experiment by scratching in patterns and light and molding the fruit with more texture to make a pleasing image.

PAGE 69 *Gifts from the Farmer's Market*
BLUE HILL, MAINE
Radishes and flowers carried to market in an
old basket made a charming still life, which I
altered with a metal nut pick while the emul-
sion was still very fluid.

PAGE 70 *Rebecca at the Door*
MILL VALLEY, CALIFORNIA
My free-spirited eighteen-month-old niece
rarely holds still. This photograph of Rebecca
nude and on the move captured her essence.
Her small body framed by the wooden door
provided appealing shapes and painterly sub-
ject matter. I froze this print so I could work
with it at a later time.

PAGE 72 *Sisters on a Stroll*
MILL VALLEY, CALIFORNIA
Katie and Emily came by to visit and were so
appealing in their matching sun hats and
overalls that I had to take their picture. The
image was frozen and manipulated later on a

warm surface with a metal nut pick. No color
was added.

PAGE 73 *Miss Jill,* CARMEL, CALIFORNIA
Jill came to my herb garden with her new
hat, coat and boots and irresistible charm in
search of flower fairies. This photograph was
moved with a toothpick immediately.

PAGE 74 *Ebony in the Light,* BLUE HILL, MAINE
Strong back lighting gave added radiance to
the innocent face of this young girl clutching
a tiny bouquet. I heavily manipulated all areas
but her face.

PAGE 75 *Life of Rachel,* BLUE HILL, MAINE
The rich textures and patterns of a lounge
chair, daylilies and the shingled house all work
together to frame Rachel with her relaxed
posture and borrowed sunglasses. Because of
the glasses even her face could be altered with
wooden and metal tools. I painted the origi-
nal with oils to enliven the colors.

What You Need to Know:
Tools and Resources, Information and Instructions

EQUIPMENT and TOOLS

1. SX Polaroid Land Camera (or check alternatives)
2. Instant Polaroid Time-Zero Supercolor film
3. Tools for manipulation
 Different tools will create different effects.
It is best to have a comfortable handle.

WOODEN TOOLS

Wooden tools are ideal for softer rendering. They are a good choice when emulsion is fluid and a blurred-edged, painterly look is desired.

 Toothpicks (use heaviest kind, replace when point breaks)
 Clay burnishing tools (comfortable to hold)
 Popsicle sticks
 Wooden matches
 Sharp bone
 Bamboo sticks
 Chopsticks
 Dull pencils
 Sharpened sticks

METAL TOOLS

These are most effective on firmer prints when more detail is desired. Using metal tools it is possible to create textures such as cross-hatching, dots and careful outlining. Images can be moved on a hard surface for several days with a metal tool.

 Crochet and knitting needles

 Scissors
 Nails
 Hairpins
 Paper clips
 Can openers
 Used Bic pen cases
 Nail files
 Ice and nut picks
 Screwdrivers
 Dental tools

ADAPTING YOUR CAMERA TO TIME-ZERO FILM

If you don't have a Polaroid One-Step Land Camera that uses Time-Zero film (the only self-developing film soft enough to alter) and you want to try manipulation, you can adapt the easily available Polaroid 600 camera to use Time-Zero film using the following procedure (instructions from Polaroid's *Test* magazine).

Take a piece of stiff paper, such as a file folder or the "dark slide" from a spent pack of Time-Zero or 600 film, and insert it halfway into the film chamber of your 600 instant camera. Be sure the cardboard covers the small metal bar that normally prevents Time-Zero film from being loaded into the camera. Then slide the Time-Zero film pack over the piece of cardboard and into the chamber. Remove the cardboard and close the film door.

Since there's a difference of two f-stops

between 600 Plus and Time-Zero film, you'll need to tape a one- or two-stop neutral density filter over the light meter of your 600 instant camera to properly expose the Time-Zero film.

Another idea: Turn your 35mm slides (or medium-format transparencies) into manipulated images. First, select the transparency from which you want to create Time-Zero prints. Take the transparency to the darkroom along with a full pack of Time-Zero film, an SX-70 or Polaroid 600 camera, an empty pack of Time-Zero film and a roll of masking tape.

Set the enlarger at 16½ and place the transparency in the enlarger, just as you would a negative. Place the empty Time-Zero pack so that the transparency will be projected onto it, and crop the image. Use the empty film pack as a guide, and outline it with tape.

Remove the empty film pack and turn out the darkroom lights. Place the full pack of Time-Zero film where the empty one was, using the tape marks as a guide. Allow this fresh film pack to be exposed for about three seconds and load it into the SX-70 camera for processing. As soon as the camera is loaded with the exposed Time-Zero film, it will automatically eject the top sheet of film. You can now turn on the lights and look at the Time-Zero image.

Now the image is ready for any kind of alteration you'd like to try. The advantage of creating images this way is that you can convert any of your transparencies. This could open up a world of great images taken with a more sophisticated camera. The disadvantages, of

course, are having to work in a darkroom and needing access to an enlarger. Although I look forward to trying this method to convert some of my 35mm images, I am so much a person of the light, of simplicity and immediacy, that I am still quite happy with my direct work.

COMPONENTS OF PAINTERLY PHOTOGRAPHY

LIGHT

I prefer to work with available natural light. Natural reflections, dappling and soft shadows all add to a painterly subject matter. SX-70 photographers such as Norman Locks prefer using a Sylvania flash bar to get even light throughout the entire subject. Flash provides maximum definition and sharpness and saturated, well-balanced color. It may also create a shadow around the subject, which Locks outlines using scratching techniques and other alterations. Sylvania flash bars are available where Time-Zero film is sold (large chain drugstores) and snap onto all SX-70 Land Cameras.

PRINTS

Prints can be made from Polaroid images in several ways:
Canon Color Laser Print Copy or *XEROX Color Copy*
- easiest
- least expensive
- most available
- limitation of size to 11 x 11 inches
- limitation of paper, but always ask for the best paper quality available (100

percent cotton is preferred, especially if you plan to paint on the print later)
· limitation of quality and control of color and print

Polaroid's Laser Print Service
P.O. Box 911
El Segundo, California 90245
1-800-421-1030
· Reproduced on photographic paper. Sizes available: 6 x 6 or 8 x 8 inches.

Re-photographing Polaroid with Negative Print Film—to Make a Copy Negative.

Medium square-format film is perfect; 2¼ x 2¼ negatives will enlarge beautifully, and 35mm is also acceptable. David Scott Leibowitz, a well-known SX-70 photographer, makes 8 x 10 internegatives and produces limited edition 20 x 20 or 36 x 36 inch Cibachrome prints.

LONGEVITY OF POLAROID ORIGINALS

(According to Polaroid's Research Division)
Polaroid prints will show very little change over time if they are stored in the dark or under moderate tungsten or subdued natural light. As with any photograph or watercolor painting, dyes are less stable when stored under bright natural or fluorescent light and will fade at a faster rate. With Polaroids whites tend to yellow but other colors are more stable. The amount of fading depends on both the amount of time exposed and the intensity of the light. Minimizing these two factors will help make your prints last.

Using a photographic lacquer that contains a UV absorber, such as McDonald Pro-tecta-cote™, will improve stability of image. Using a UV absorber such as an acrylic plastic frame to filter ultraviolet light will also help protect the image.

POSSIBLE PROBLEMS— TROUBLESHOOTING

If bright greenish-yellow spots or lines appear on your Polaroid print, the roller bar in the camera needs cleaning (use a damp cloth). Water-soluble chemicals can build up on the roller and create pressure that will squeeze the image unevenly.

Too little light will cause a blurred image. Try using a tripod and cable release or a flash bar.

Note: Time-Zero film contains a caustic developer reagent. When manipulating the emulsion, avoid cutting into the film's surface and releasing the reagent.

If you try the stained glass transparency idea, use rubber gloves and lots of running water, and treat the image gently.

TECHNIQUES

PAINTING

If you feel that your manipulated image would improve with the embellishment of paint, I suggest you begin with an 8 x 8 or 11 x 11 inch Canon color laser print on a non-slick paper, preferably 100 percent cotton. You can try rubbing Marshall's photographic oil colors into areas you want to enhance using cotton swabs, not brushes. I make my own very tiny swabs for detail areas with toothpicks and cotton. I always set out my

paint palette on a white porcelain plate and blend my colors for more rich variety. Very little paint is required. Building up layers of rubbed-in color is more effective than applying a thick, gooey layer.

Clear extender can be added to any color to make the color more transparent—like adding water to watercolor paints. Opaque colors can be made by adding white. P.M. solution is used to pick up color like a liquid eraser. You can use this same method on the Polaroid originals, but you must first coat the slick surface with Marshall's pre-color spray, thus dulling the surface and giving it enough "tooth" to accept the colors.

Very tiny cotton swabs are necessary for the three-inch square image. Marshall's photographic color pencils are also available. Their fine points make them easier to use than oils, but the texture changes and colors are much more difficult to mix. It is important to experiment and have many options to develop your own creative expression; playing without attachment to the outcome, pushing until the image is ruined, will teach you to experiment to your limits.

Other art materials I have found it fun to use on my enlarged prints are French oil pastels, including iridescent and metallic colors; Prismacolor pencils; colored inks, including pearlescent; and gouache. If I first spray my laser print or Cibachrome print with Marshall's pre-color spray, I can use a wider array of art materials. Laser prints require only a very light coating. A heavy coat will dissolve the inks and further distort the image.

Watercolors and dry pastels are difficult to apply on the print surface unless the paper is somewhat absorbent and toothy.

If you paint your print, Marshall's Duolac solution can be applied with cotton swabs to re-coat the surface and restore the luster that was dulled by the pre-color spray. Duolac is like a quick-drying varnish that will also help protect the print. This seems especially necessary when working with Polaroids and Cibachromes. Several layers can be applied, and the effect can be shiny or pearl. I've experimented to build up luster on reflected surfaces, like water or light areas, which adds a subtle depth to the original image.

MAKING STAINED GLASS IMAGES
Here is another way to play with an image. With rubber gloves on (to avoid touching the caustic developer reagent, which is like white chalk sandwiched between the mylar cover and the color dyes and backing), over the sink with running cold water, cut the paper bottom border off the Polaroid print. Peel the front mylar off the black back. Gently wash off all the white reagent. If you rub hard, you will scrape off the exposed image.

After rinsing, allow the mylar print to dry. It will be like a large transparency. Transparent inks or dyes can be applied to the front or back surface to strengthen color and add texture to the print. You can then remount the print on white paper as an image for a card, journal cover or print.

CREATING POLAROID TRANSFERS

Polaroid transfers are another artistic medium with limitless possibilities open to creative, risk-taking photographers. Basically, an image is exposed on Polaroid Polacolor film. Types 668, 669, 59, 559 and 809 work for the transfer process. The "9" series produces the most consistent results. These films are the peel-off-the-back type of Polaroid film. Instead of allowing the image to develop on the Polaroid print paper, you interrupt the process and take the gooey chemical side (which is usually discarded) and transfer it onto watercolor paper, rice paper, silk, drafting vellum or even a paper bag. Each surface will give something different to the image. The paper can be wet or dry, again changing the effect. Details for this process can be obtained from Polaroid's customer service hotline (1-800-343-5000).

To create a Polaroid transfer from your altered Time-Zero print, you must make a copy slide of your print. You can do this with a tripod and close-up lens or copy stand. With your copy slide of the original (or with any slide you want to try) you can use a Vivitar Instant Slide Printer (available through most good camera stores). This little machine exposes 35mm slides onto Polaroid type 669 film to create a 3¼ x 4¼ image. Another similar instant slide printer is the Daylab II/Polaroid Slide Printer, which makes 4 x 5 prints on peel-apart 559 or 545 film. (Call Daylab at 714-988-3233 to purchase or for more information.)

Another idea is to make a color copy of your original manipulated Polaroid on a transfer sheet (the same technique used in printing photographs on T-shirts) and then iron the transfer onto heavy watercolor paper such as Arches. The watercolor paper will provide a substantial print, which can then be further colored with watercolors, pencils, photographic oils and dry or oil pastels. This process is expensive and a bit risky in terms of results, and finding a firm with a Canon color copier that makes transfers is difficult in some areas. When it works, however, it produces a beautiful softness.

RESOURCES

TECHNICAL SUPPORT
Polaroid Technical Assistance
　　784 Memorial Drive, Cambridge, Massachusetts 02139
　　Hotline: 1-800-225-1618 (8 A.M.– 8 P.M. E.S.T.)
Polaroid Customer Service Hotline
　　1-800-343-5000

PUBLICATIONS
Polaroid Guide to Instant Imaging—Advanced Image Transferring
　　Informative publication on making transfers. Call the Polaroid customer service hotline for a free booklet.
Test
　　The instant film and equipment magazine for professional photographers. It offers inspirational examples of creative uses of Polaroid films and alterations of SX-70 prints and Polaroid transparencies.

Available by writing to: Kent Buschle, Polaroid Corporation, 575 Technology Square, 2nd Floor, Cambridge, Massachusetts 02139.

Familiar Subjects

A book on Polaroid SX-70 impressions by Norman Locks, The Headlands Press, Inc., San Francisco, California, 1978.

CAMERAS

Four Designs Company

9400 Wystone Avenue, Northridge, California 91324

1-800-544-3746 (orders only)

818-882-2878 (for information)

Sells both basic and modified SX-70 cameras. You can order a customized camera for use with studio flash lighting or to allow for multiple exposures on a single piece of film. When I graduated from my $5 plastic yard sale camera, I bought a Polaroid Sonar One-Step SX-70 Land Camera here. This camera allows me to focus from 10.4 inches to infinity, and it will accept a flash bar.

Graphic Center

P.O. Box 818, Ventura, California 93002

1-800-336-6096 (for orders, information and a free catalog)

Graphic Center offers SX-70 cameras as well as a variety of accessories, including a close-up kit, cable releases, polarizing filters and telephoto lenses.

Precision Repair

Chicopee Falls, Massachusetts

413-598-8005

Polaroid's authorized service center. Call here if you have or acquire an old SX-70 camera in need of repair.

FILM

Polaroid Time-Zero SX-70 film is the only kind that can be altered. Film packs of ten photos or double packs of twenty photos are available in large convenience-type drugstores, K-Mart stores and some photography stores. Since this is the older style of film and Polaroid is no longer manufacturing SX-70 cameras, the film is not as readily available as some types.

ART SUPPLIES

Marshall's photographic oils, coloring pencils and liquid retouch colors; Marshall's pre-color spray, necessary to directly color Polaroids; and PMS (prepared medium solution) to clean off excess pigment and to prepare areas for pencil are available through:

Light Impressions

439 Monroe Avenue, Rochester, New York 14607-3717

1-800-828-6216 (orders only)

1-800-828-9859 (customer service)

Monday through Friday, 9 A.M. to 5 P.M. E.S.T.

716-271-8960 (technical assistance) for good, solid advice. Very helpful.

A good source for French oil pastels, watercolors, inks, metallic pigments and all kinds of art papers and frames is Daniel Smith's catalog of artists' materials:

4130 1st Avenue South, Seattle, Washington 98134

1-800-426-6740, Monday through Friday 5 A.M.–6 P.M. P.S.T., Saturday 9 A.M.–5 P.M.